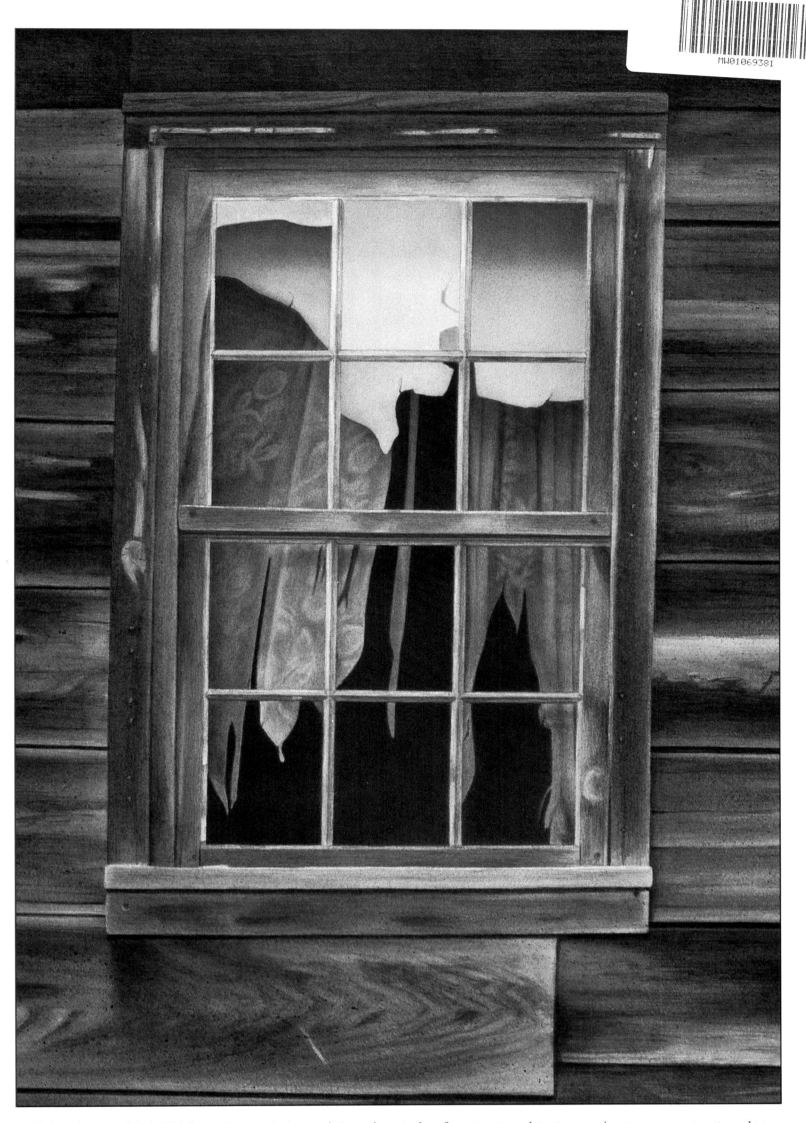

This painting, titled *Old Lace,* demonstrates an interesting study of contrasts and textures using transparent watercolor paint on 140-pound cold-pressed paper. The darker areas were painted first, with special care to paint around and save the lighter areas until last.

Introduction

Nothing brings greater pleasure—or, often, more frustration—than the creation of art. But for those of us who have been bitten by the creative bug, we would have it no other way.

I hope that the projects shown in this book will give you some insight into the methods that I use to paint different landscape subjects in watercolor. By breaking the painting process down into an easy step-by-step approach, even seemingly complicated subjects can be mastered with ease.

Starting with a few basic landscape elements, such as skies, water, trees, and rocks, we will work up to more intricate landscape paintings that include buildings or animals. With practice, that blank piece of watercolor paper will become much less formidable.

There are times, however, when even the experienced artist has dif-ficulty with a section of a painting. It is sometimes helpful to leave t painting alone for a while and look at it again later with a fresh ey Sometimes an artist friend can also provide that fresh eye and offe new point of view. If a friend is not available, try looking at the pai ing upside down or at its reversed image in a mirror. All of these thin will force you to look at the painting from a new perspective and he you resolve the problem areas.

So gather your brushes and paints and get started! Set your goa high, but learn to be forgiving of yourself. Not every painting w become the masterpiece that you envisioned. After all, one lifetime not long enough to learn everything there is to know about art. Lea as much as you can, but most of all, enjoy your art and have fun crea ing it. Happy painting!

I dedicate this book to my husband, Larry, who tirelessly hauled tons
of gear to art shows, constructed ingenious rain- and wind-resistant displays,
assembled countless numbers of picture frames, and endured many late
meals so that I could find the time to paint.

Studio Materials

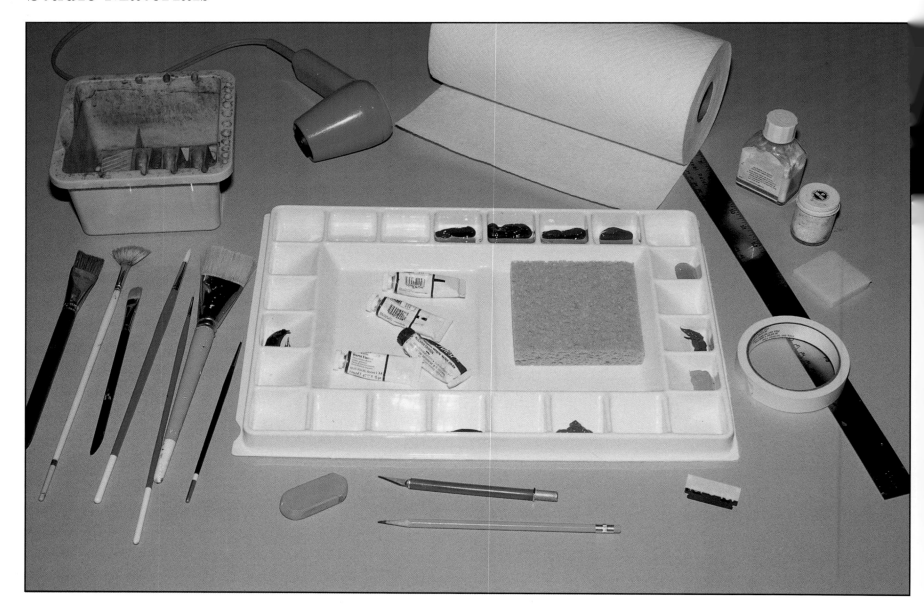

Watercolor Paints

Transparent watercolors in tubes have been used for the projects in this book. You may use either professional or student grade colors. However, as with most art supplies, the higher the quality, the better the results.

The following colors are used throughout this book: cadmium red, alizarin crimson, Hooker's green dark, ultramarine blue, raw umber, burnt umber, burnt sienna, raw sienna, yellow ochre, and cadmium yellow light. Note: Opaque white, which is available in both tubes and jars, has been used for certain special effects in some of the projects.

Palette

Choose a palette with a large mixing area and separate wells in which to squeeze out and store your paints. A lid for your palette not only keeps your paints clean when stored but also allows for easier transport (see photo on page 2).

Brushes

Buy the best brushes that your budget will allow. A 2" flat, 1/2" flat, #4 round, and #1 round sable or synthetic sable brush will get you started. A 1" bristle fan is also helpful when painting subjects such as grasses. For more information, refer to Walter Foster's *Watercolor and Acrylic Painting Materials*, AL18.

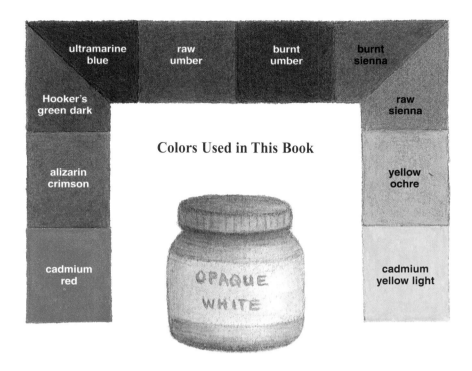

Colors Used in This Book

ultramarine blue · raw umber · burnt umber · burnt sienna · Hooker's green dark · raw sienna · alizarin crimson · yellow ochre · cadmium red · cadmium yellow light · OPAQUE WHITE

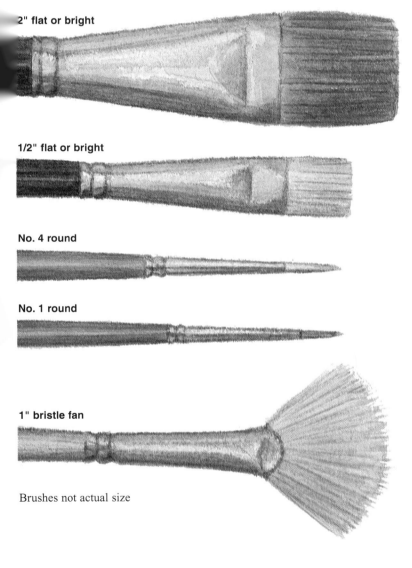

2" flat or bright

1/2" flat or bright

No. 4 round

No. 1 round

1" bristle fan

Brushes not actual size

Paper

For best results, use a good quality rag (cotton) watercolor paper. This paper, which is available in several weights and surface textures, can be purchased by the sheet or in blocks. A good all-around choice for most subject matter is 140-pound cold-pressed paper; it has a medium texture and is relatively inexpensive. However, you need to prestretch paper of this weight to help prevent wrinkling and buckling during the painting process. (See paper stretching instructions below.)

How to Stretch Watercolor Paper

First, soak the sheet of watercolor paper in a tub of cool water. After twenty minutes, lift the paper out by a corner, allowing most of the water to run off the paper.

Next, starting in the center and working toward the corners, staple, clip, or tack the wet paper to a wooden support (such as a scrap of plywood or paneling). Space the staples about two inches apart around the edges of the four sides of the paper.

The paper will be tightly stretched and ready for painting when completely dry.

Note: No stretching is necessary when using a heavyweight paper such as 300-pound watercolor paper or watercolor board. This weight is thick enough to prevent any buckling when paint is applied to it. It is, however, somewhat more expensive than the 140-pound watercolor paper.

Miscellaneous Supplies

You will find the following supplies helpful: eraser, art knife, pencil, masking tape, ruler, pick-up eraser, opaque white paint, masking fluid, paper towels, hair dryer, water container, a sponge, and a razor blade (taped on one side to protect fingers).

Landscape Elements: SKIES

The wet-on-wet technique (applying wet paint to a wet surface) is an effective way to paint beautiful skies in watercolor. Using a 2" flat brush, start with a light wash (a very thin, watery mixture) of color—yellow ochre for the **sunny sky** (left) or burnt sienna for the **stormy sky** (right). It is important that the sky area is thoroughly dampened with this initial wash to prevent the paint from drying into hard edges when the clouds are added.

While the paper is still wet, add a few clouds made from a mixture of ultramarine blue and a tiny amount of burnt umber. Make the cloud mixture for the sunny sky a little lighter than that of the stormy sky by adding a bit more water to the mixture. Use random strokes to apply the paint and leave a few light areas of sky showing through the clouds. To create a feeling of space, paint the clouds larger and darker at the top of the sky, gradually fading them at the horizon.

While the sky is still damp, work quickly to add the remaining clouds shapes. Mix a little more burnt umber into the cloud mixture for the stormy sky in this final step. After a few minutes, as the wet paint begins to dry, the cloud shapes will diffuse and appear much lighter and softer. The trick here is not to overwork the paint. After a little practice, watercolor skies will seem to paint themselves.

andscape Elements: WATER

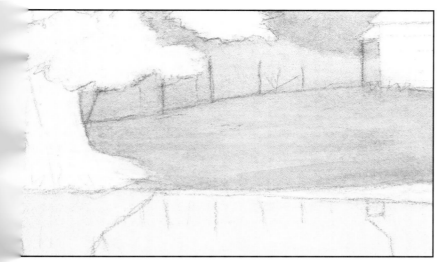

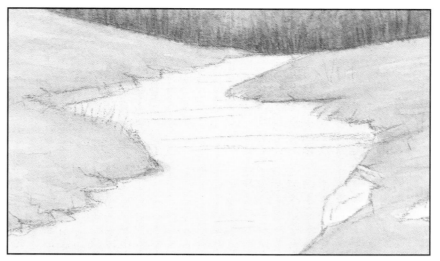

till Water: Paint in the background with ultramarine blue, burnt mber, yellow ochre, and Hooker's green. Apply a yellow ochre wash the water. Notice how the still water of the pond reflects an upside-own mirrored image of the bank and surrounding objects.

Running Water: First, paint in the background and bank with mixtures of ultramarine blue, yellow ochre, Hooker's green, burnt umber, and burnt sienna. Paint a light wash of yellow ochre over the water and allow it to dry.

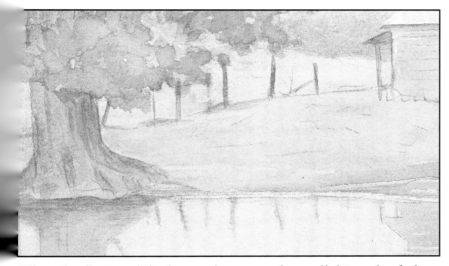

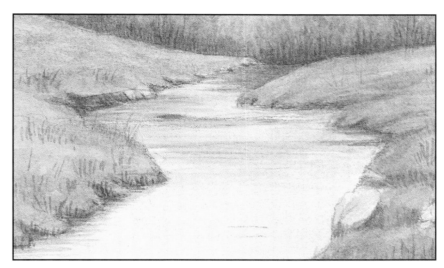

When the first wash is dry, apply a second very light wash of ultramarine blue to the water area. After it is dry, add the reflections of the tree, fence posts, and building with a mixture of ultramarine blue and burnt umber.

Although the movement of the creek water does not create mirrored images like the still water, it does produce broken shadows of the bank's edge and rocky bottom. Paint the shadows with a mixture of ultramarine blue, Hooker's green, and burnt sienna.

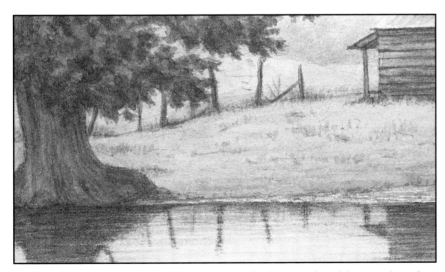

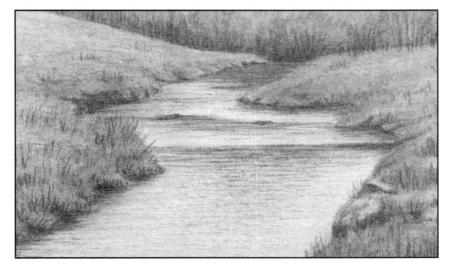

Next, add a few horizontal streaks of ultramarine blue and a tiny amount of burnt umber to the water to create small surface ripples. Finally, use a razor blade to scratch out a few light reflections on the surface of the water and along the bank (see page 14).

Because water also reflects the color of the sky, add a little ultramarine blue to it using the drybrush technique (see page 10). Allow the brush to bump across the surface of the paper to suggest the rippling motion of the water.

5

Landscape Elements: TREES

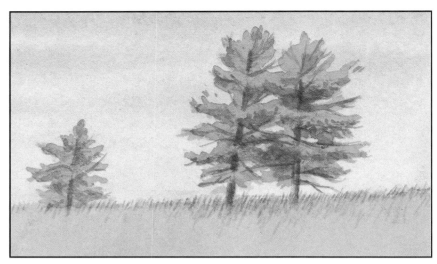

Pine Trees: Paint in the broad shapes of the pines using ultramarine blue, burnt umber, Hooker's green, and raw sienna. After it is dry, add the shadow areas under the limbs with a darker mixture of the same colors. Add burnt sienna to the mixture for the tree trunks.

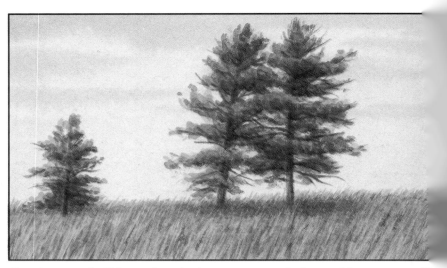

Continue to build up the shadow areas, and then add some small limbs for detail. Take care to leave the tops of the branches lighter where the sunshine hits them. Finally, add a touch of burnt sienna to the branches to warm them a bit.

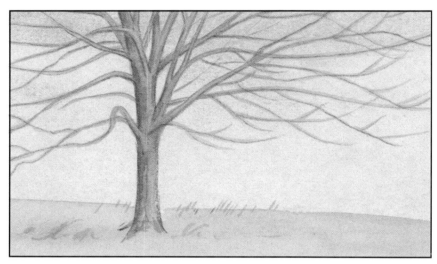

Broadleaf Trees without Foliage: Starting with a light mixture of burnt umber and ultramarine blue, paint in the trunk and limbs. When dry, use the same mixture to add shadows to the side of the tree.

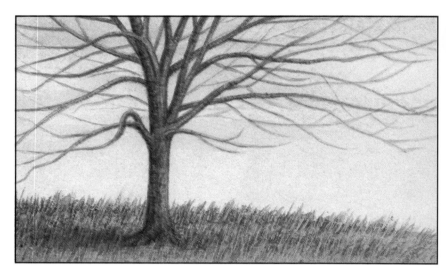

Add a little burnt sienna to finish the details on the trunk and limbs. Gradually fade out the color and the thickness of the branches as you near the tips.

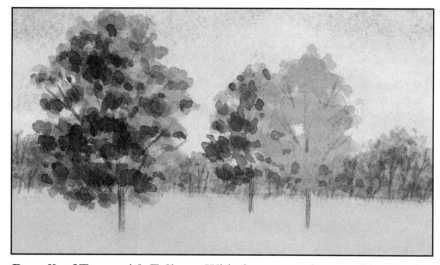

Broadleaf Trees with Foliage: With the same colors used in the pine tree demonstration above, paint in the light leaf masses using short, dabbing strokes. Build up the tree shapes as you continue. When dry, lightly paint in the trunks and limbs and add darker foliage in the shadow areas.

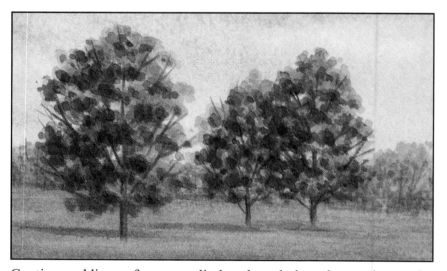

Continue adding a few more limbs; then darken the trunks on the shadow sides of the trees. Dab a little yellow ochre onto the treetops to suggest sunlight on the leaves. Finish with a few dots of burnt sienna dabbed here and there in the foliage.

Landscape Elements: ROCKS, PEBBLES, AND WEEDS

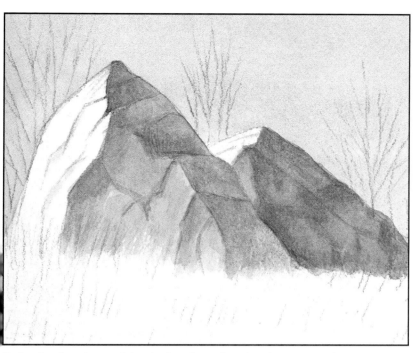

Paint in the sky and let it dry (see the sky demonstration on page 4). Then mix a light wash of ultramarine blue and burnt umber and apply it to the shadow sides of the rocks. Continue building up the shadows with light washes of color, letting the paint dry between applications. Paint in the cracks with a small round brush.

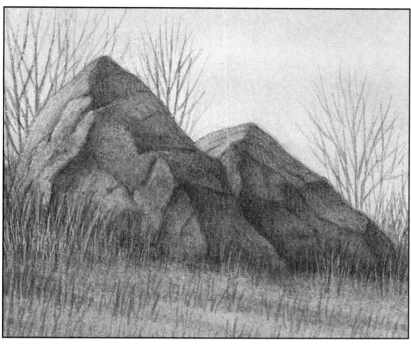

Next, place a light wash of color on the sunny side of the rocks and let it dry. For texture, drybrush (see page 10) a little color onto the rock surfaces and scrape off a few highlights with a razor blade (see page 14). Finally, paint in the bushes and grasses using upward strokes.

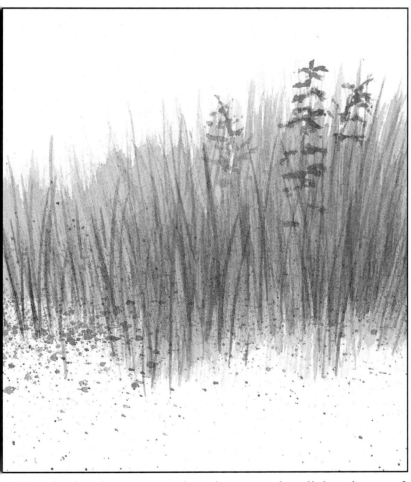

With a fan brush, use upward strokes to apply a light mixture of Hooker's green, ultramarine blue, and burnt umber. When this has dried, switch to a small round brush and add a few darker grass blades (still using upward strokes) made from the same colors. Also begin painting in a few weed shapes and spatter some color on the ground to suggest pebbles (see page 10).

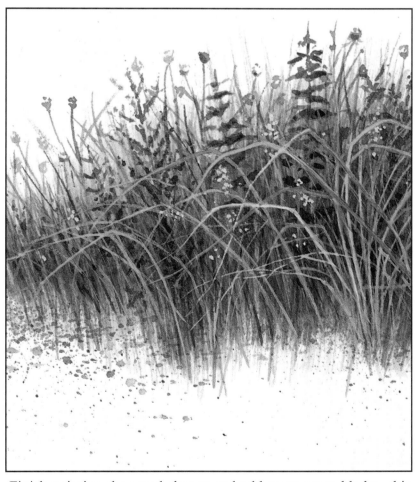

Finish painting the weed shapes and add more grass blades, this time using raw sienna for their color. When the background grasses are finished, paint in the foreground grasses using raw sienna, Hooker's green, and burnt umber mixed with opaque white. For a final touch, dot in a few flowers using opaque white tinted slightly with raw sienna.

Lesson 1: *BLUESTONE LAKE*

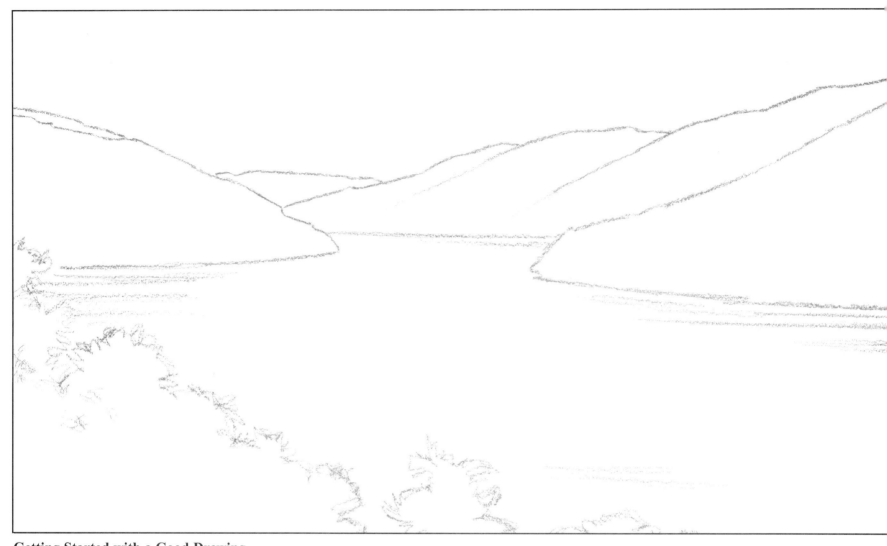

Getting Started with a Good Drawing

An accurate pencil drawing makes watercolor painting much easier. First, use a ruler to draw a box on your paper that will be the size of your painting. Apply strips of masking tape around the outer edges of the box to create a border or edge that will remain free from paint.

Now lightly sketch the drawing in pencil or trace the drawing onto a sheet of tracing paper and transfer it to your watercolor paper with graphite transfer paper. Graphite paper is similar to ordinary type-writer carbon paper except that it produces a soft graphite image instead of a greasy carbon mark. Do not use carbon paper on your watercolor painting; the paint will not cover the carbon lines! You can make your own graphite transfer paper by rubbing graphite from a soft pencil onto one side of a sheet of tracing paper or other thin paper.

Now you are ready to begin painting.

Beginning the Painting

Begin with a light wash of yellow ochre brushed across the sky area with a 2" flat brush. On this wash, apply another light wash of ultramarine blue and a small amount of burnt umber, gradually fading the color toward the bottom of the sky. Allow the sky to dry completely.

Next, mix a slightly darker mixture of ultramarine blue and burnt umber, and with a small round brush, begin painting the background mountains. Add a little Hooker's green to the mixture for the middle and foreground mountains.

When dry, mix a very thin wash of opaque white and carefully apply it with the 2" brush over the entire sky area and background mountains. Be careful not to disturb the underlying painted areas of the mountains.

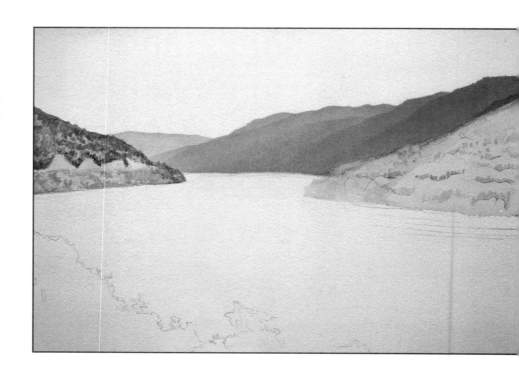

he opaque white wash applied in the previous step adds
misty effect to the background. Notice also how the
ountains become darker and warmer in color with more
sible texture as they get closer to the foreground.

Continue painting the middle and foreground moun-
ins, then add a little raw sienna to the original mixture.
se raw umber for the bare spots on the mountain on the
ft side.

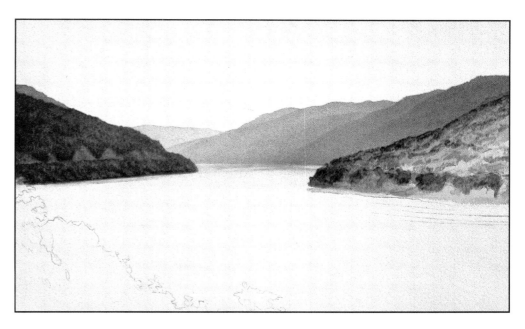

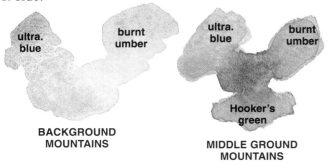

ow paint the water, starting with a yellow ochre wash
llowed by a second wash of ultramarine blue and burnt
mber (similar to the method used to paint the sky).
hen these washes are dry, add ripples with darker mix-
res of ultramarine blue and burnt umber.

Finally, add a little yellow ochre to a darker mixture
the mountain colors and paint the foreground trees.

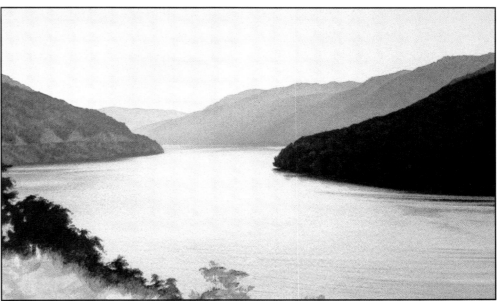

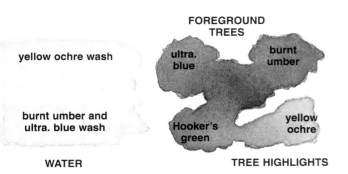

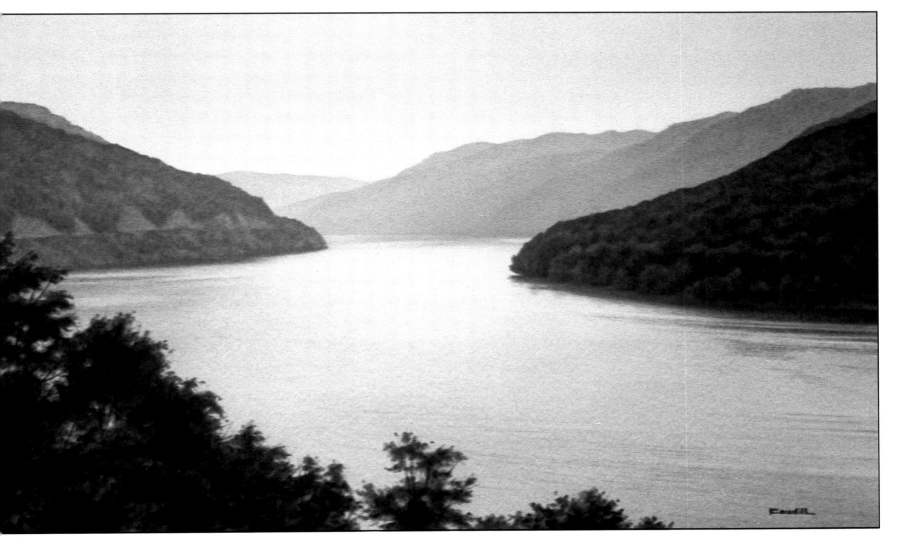

Lesson 2: *BARN HINGE*

This is a good example of a subject that may have been overlooked for a painting. With a closer look, however, you will find a subtle kind of beauty in the intricate patterns and textures of the weathered wood and rusted metal.

This entire painting can be painted with just four colors: ultramarine blue, burnt umber, burnt sienna, and raw umber. Use ultramarine blue and burnt umber mixed together in varying amounts and consistencies to produce both the warm and cool grays of the barn wood and to create a neutral black (see below). Also use these grays to tone down and deepen the other color mixtures.

Start by painting the background with a mixture of ultramarine blue, burnt umber, and burnt sienna. It will take several layers of paint (drying between each layer) to obtain the rich dark color. It is better to build the color gradually rather than to apply it too heavily in one application.

Next, apply a light wash of raw umber to the barn boards. When this wash has dried, use a small brush to paint the tiny cracks, knots, and shadow areas with mixtures of burnt umber and ultramarine blue. Add washes of burnt umber, ultramarine blue, and burnt sienna where needed to build up the color of the boards. Create texture by using the drybrush and spattering techniques illustrated below right.

Finally, paint the rusty metal parts with a wash of burnt sienna. When dry, add texture and detail with mixtures of burnt sienna, burnt umber, and ultramarine blue.

Note: With the exception of delicate washes, such as those painted in sky applications that need to soften and dry naturally, a hand-held hair dryer can be used to speed up the drying time of the paint between applications.

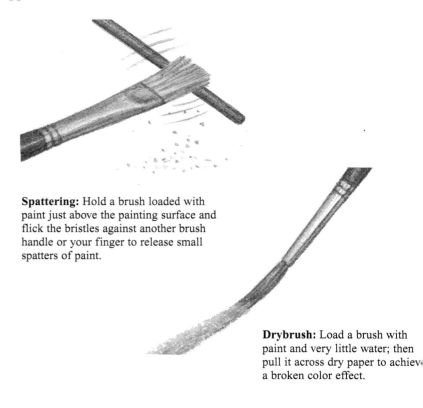

Spattering: Hold a brush loaded with paint just above the painting surface and flick the bristles against another brush handle or your finger to release small spatters of paint.

Drybrush: Load a brush with paint and very little water; then pull it across dry paper to achieve a broken color effect.

warm gray　　　**cool gray**　　　**black**

raw umber　　**ultramarine blue**　　**burnt sienna**

burnt umber

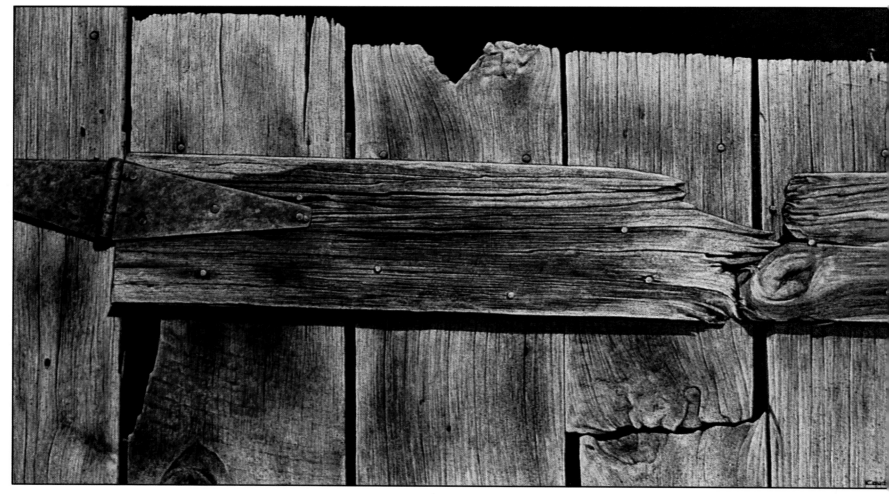

Lesson 3: *ABOVE THE FALLS*

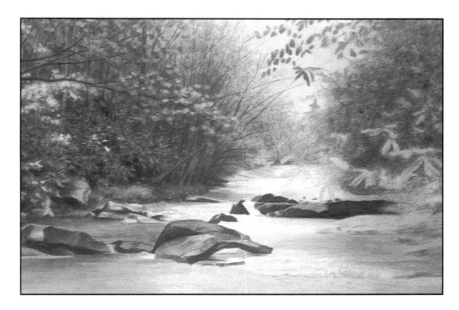

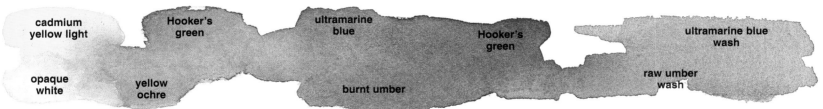

cadmium yellow light · opaque white · Hooker's green · yellow ochre · ultramarine blue · burnt umber · Hooker's green · ultramarine blue wash · raw umber wash

Start with a yellow ochre wash over the sky and background trees. When dry, add the tree limbs and foliage, working from the background forward. The background will be lighter in color and less defined than the foreground.

When building the complicated areas of the foliage, use a little opaque white mixed with your transparent color for some of the brighter top leaves (rather than painting around all the areas to be left light).

Notice that the water looks brown instead of blue. This is because the water is shallow and the creek bottom is visible from the surface.

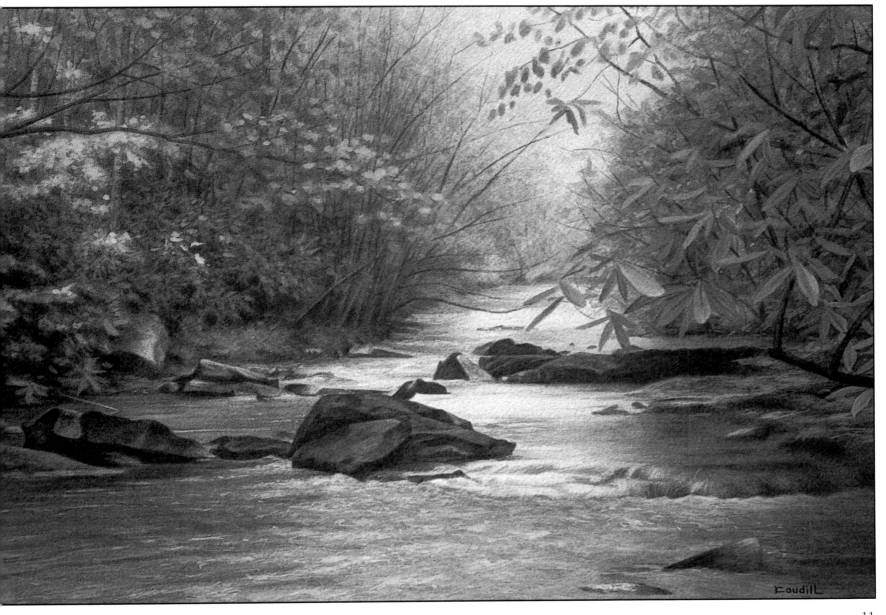

Caudill

Lesson 4: *MOURNING DOVES, WINTER*

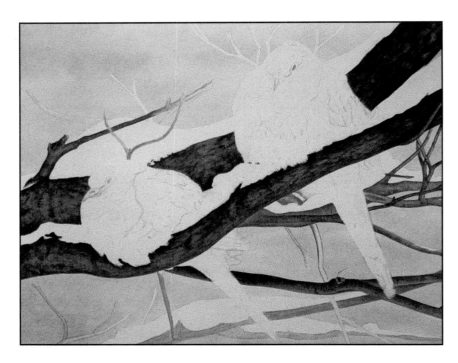 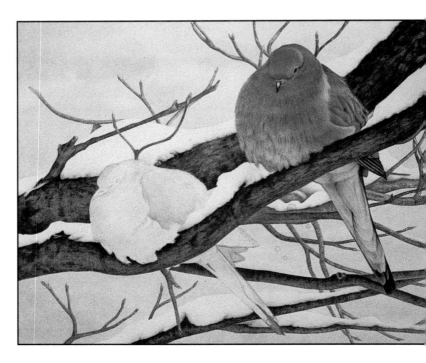

Brush liquid masking fluid onto the snow, small branches, and outer edges of the doves to keep them free from paint while the background is being painted. Before dipping into the fluid, wet your brush and rub it on a bar of soap. This will protect the bristles and allow for easier cleaning. To remove the masking fluid once it has dried, rub it with your fingertips or remove it with a pick-up eraser.

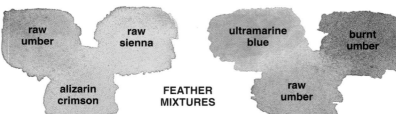

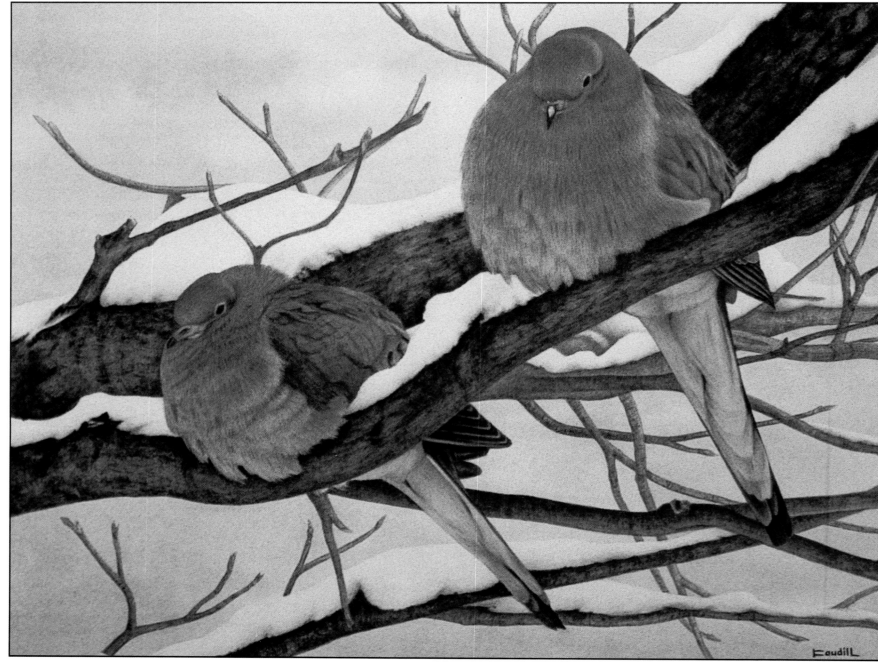

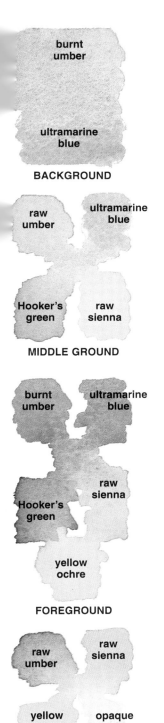

burnt
umber

ultramarine
blue

BACKGROUND

raw
umber

ultramarine
blue

Hooker's
green

raw
sienna

MIDDLE GROUND

burnt
umber

ultramarine
blue

raw
sienna

Hooker's
green

yellow
ochre

FOREGROUND

raw
umber

raw
sienna

yellow
ochre

opaque
white

TASSELS

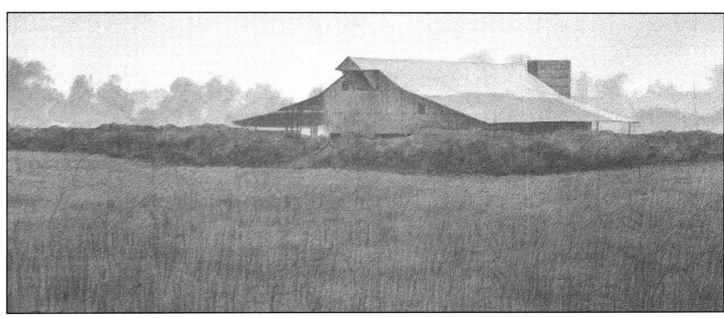

Keep your colors very diluted and pale when painting the background areas. To create a misty look, apply a thin wash of opaque white over the painted sky and distant trees. Use steadily warmer mixtures of color as you move toward the foreground.

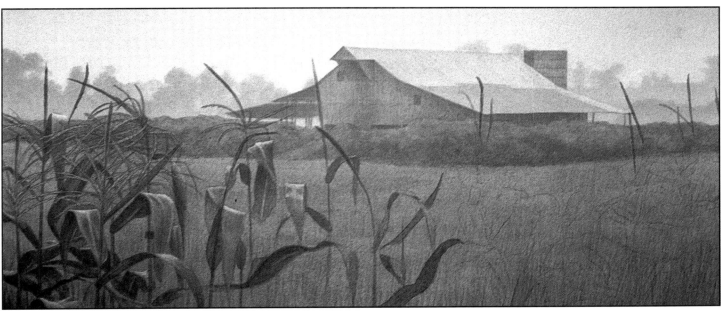

Reserve your darkest color mixtures for the shadowed areas of the cornstalks. Add a little opaque white to your color mixture for the tassels of the corn.

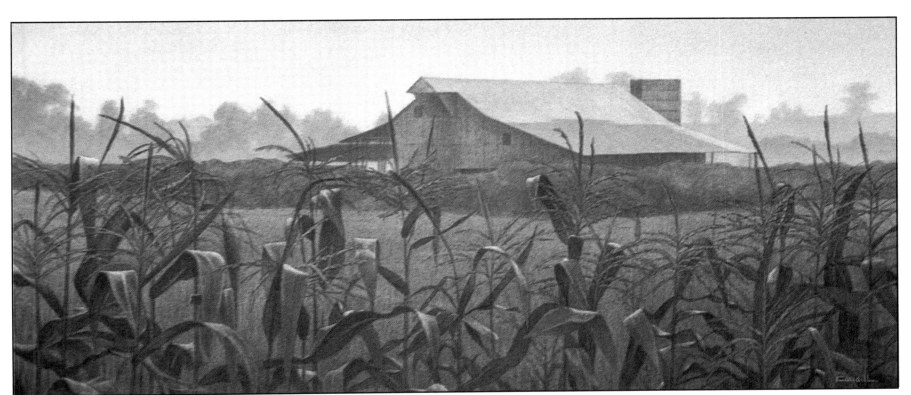

Lesson 6: *LITTLE RED WAGON*

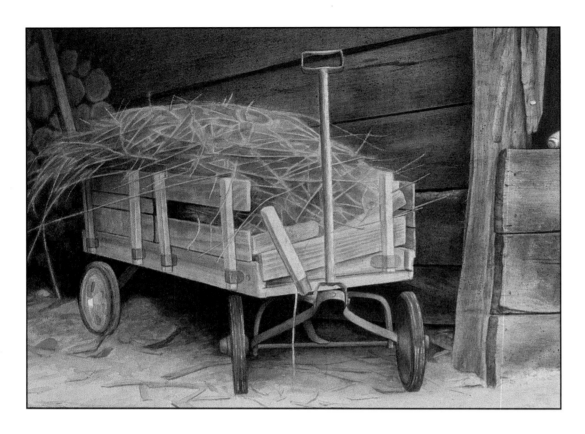

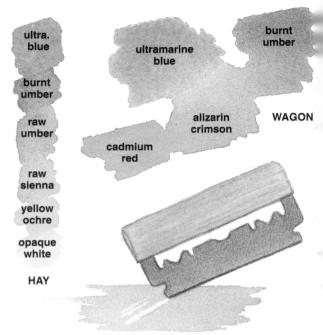

Scraping Out: Scrape or scratch the painted surface with the shar[p] corner of a razor blade, removing the paint down to the paper. Caution: A double-edged razor blade should be taped on one side t[o] prevent accidental cuts to fingers.

First paint the dark background areas of the old barn interior and the shadowed area beneath the wagon. It will take several color applications—drying between each application—to build up the dark color.

The hay will be the most difficult part of this painting. It should be treated as a simple mass of light and dark forms before any detailing

is added. Then a few bits of hay can be scraped out with a razor blade and others can be emphasized by adding opaque white to the transparent color mixture.

Finish by painting the wagon and foreground area, adding texture to the ground with the spattering technique explained previously.

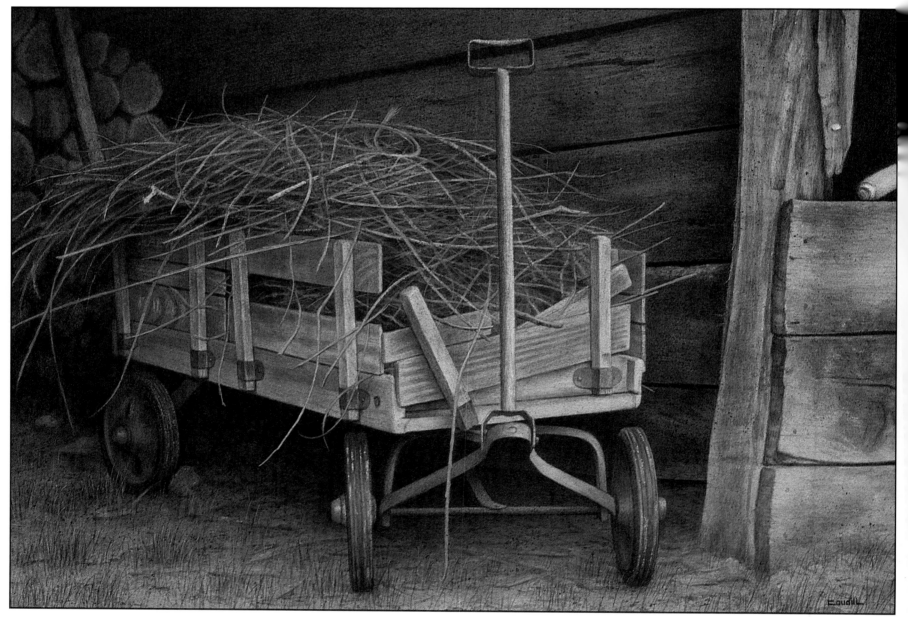

Field grass is the tall, weedy grass that grows in open fields and around old barns. It can vary in color from green or yellow to almost brown, depending upon the season of the year; it is sometimes strewn with wildflowers. Although it looks as if it would be difficult to paint, field grass is very easy to paint once you get the hang of it. Use a stiff bristle fan brush to create the illusion of many meticulously painted strokes.

Working from the background forward, use the fan brush to paint the grass with a thin wash of raw umber applied with upward strokes. Gradually increase the length of the strokes as you work your way down into the foreground.

When the first wash is dry, repeat the process three or four times, darkening the color slightly with ultramarine blue and burnt umber for the shadow areas and warming it with burnt sienna here and there.

Next comes the detailing, which is done with a small fine-pointed round brush on dry paper. Using upward strokes once again, paint in a few random grass blades with your shadow color and some Hooker's green. Then spatter a bit more of the color into the grass to suggest seed pods and weeds. (Wildflowers can be spattered on in the same way by mixing their color with opaque white.)

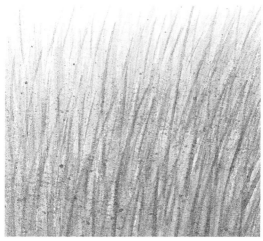

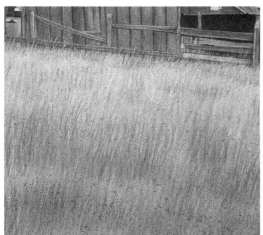

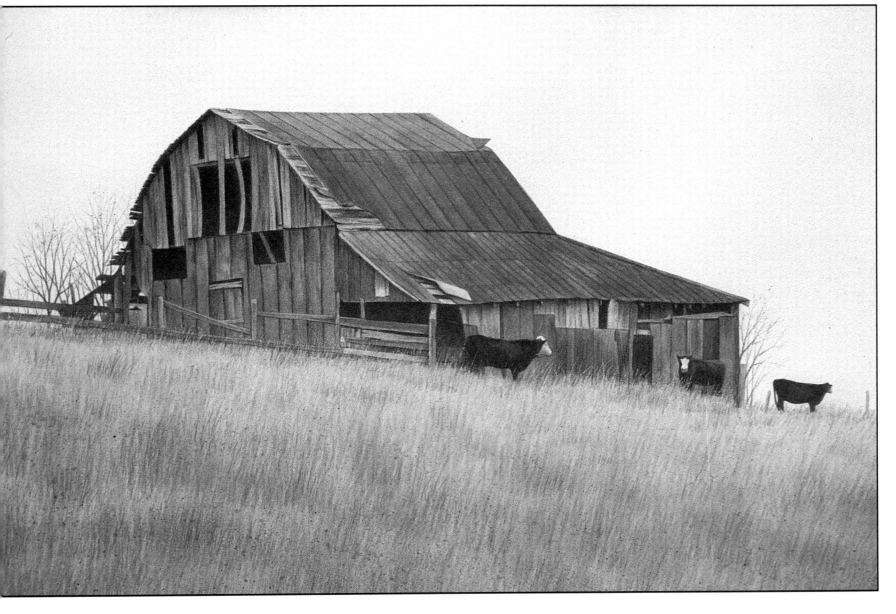

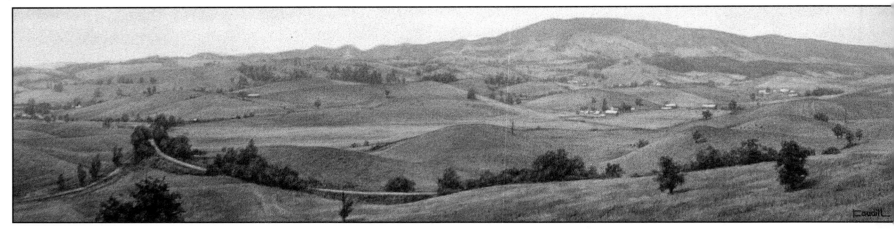

When taking photographs from which to paint, you will find it is difficult to take one of a panoramic view without a wide-angle lens. If you don't have one of these lenses for your camera, take several overlapping shots of the scene and tape them together. It works great and gives you the opportunity to create an unusual-sized painting.

In landscape painting—especially when painting expansive panoramic views—it is important to understand the rules of aerial perspective if you want to create a convincing three-dimensional illusion of space. Quite simply: Foreground objects are darker and more distinct. They are also warmer in color and tinted with yellows. Objects in the middle distance are paler and less distinct than those in the foreground. These objects tend to be cooler in color and tinted with reds. The background objects are the palest and coolest in color. They are less distinct than those in the middle distance and are tinted with blues.

Lesson 8: *PIPESTEM VIEW*

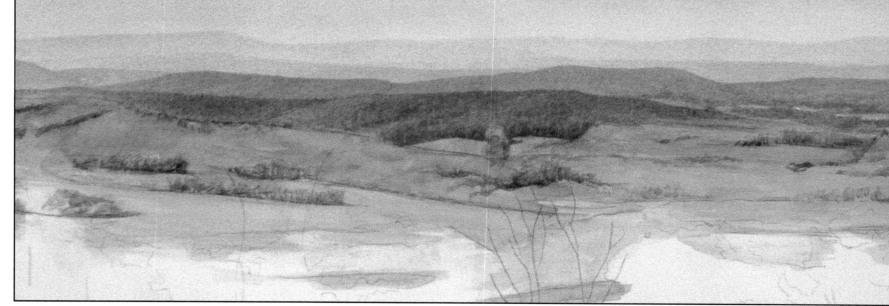

Start by painting a yellow ochre wash for the sky. On top of this wash, paint another light wash of ultramarine blue, gradually fading it out as it reaches the tops of the mountains. Let this dry completely.

Next, mix ultramarine blue with a very small amount of burnt umber. Paint the most distant mountain range with this color. Note: The top of each mountain should be painted slightly darker than the bottom.

Drying between each step, paint the second mountain range a little darker than the first.

The next two mountain ranges are approaching the middle distance, and you begin to see more detail and slightly warmer colors in them. Use a little more burnt umber with your ultramarine blue mixture, introducing a little Hooker's green at this time. Paint the bare patches with raw sienna, burnt umber, and Hooker's green.

After drying, take a 2" flat brush and carefully paint a thin wash of opaque white over the sky and the mountains completed so far. This creates the illusion of atmospheric haze in the distance. When finished, let dry, and then begin painting the last mountain range and ground.

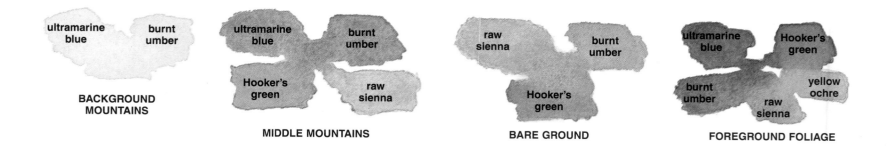

ultramarine blue burnt umber

BACKGROUND MOUNTAINS

ultramarine blue burnt umber Hooker's green raw sienna

MIDDLE MOUNTAINS

raw sienna burnt umber Hooker's green

BARE GROUND

ultramarine blue Hooker's green burnt umber raw sienna yellow ochre

FOREGROUND FOLIAGE

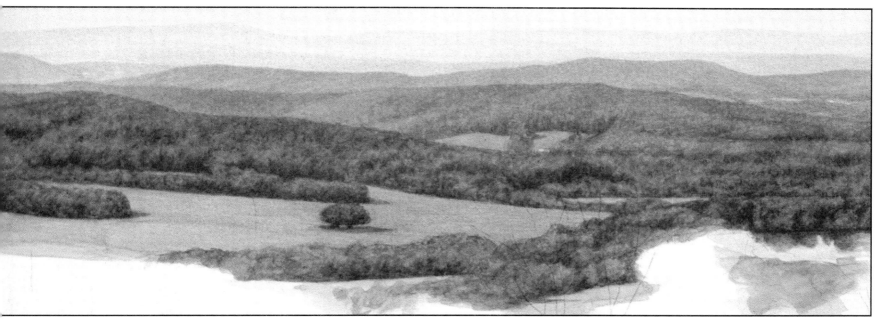

By this time, you should be able to start to see the benefits of aerial perspective in your painting. The mountains have taken on a much warmer color with the addition of raw sienna, and the trees are becoming darker and more distinct.

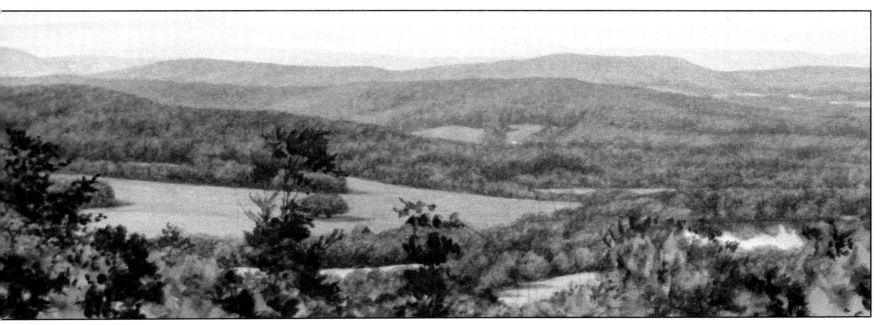

Finish up the middle ground by adding a small pond painted with a wash of ultramarine blue and burnt umber. Paint in the reflections (as shown on page 5). The foreground trees add depth and interest to this little painting.

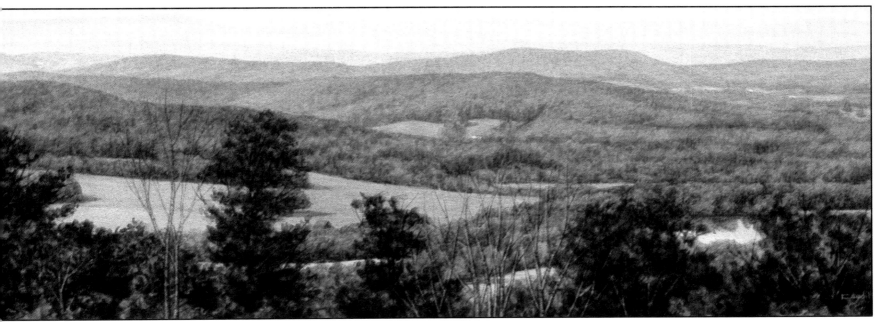

Paint the shadowed leaf areas with your darkest mixture of tree color, highlighting the sunlit areas with yellow ochre. (See page 6 for instructions on how to paint trees.) Add a few bare limbs, and the painting is complete.

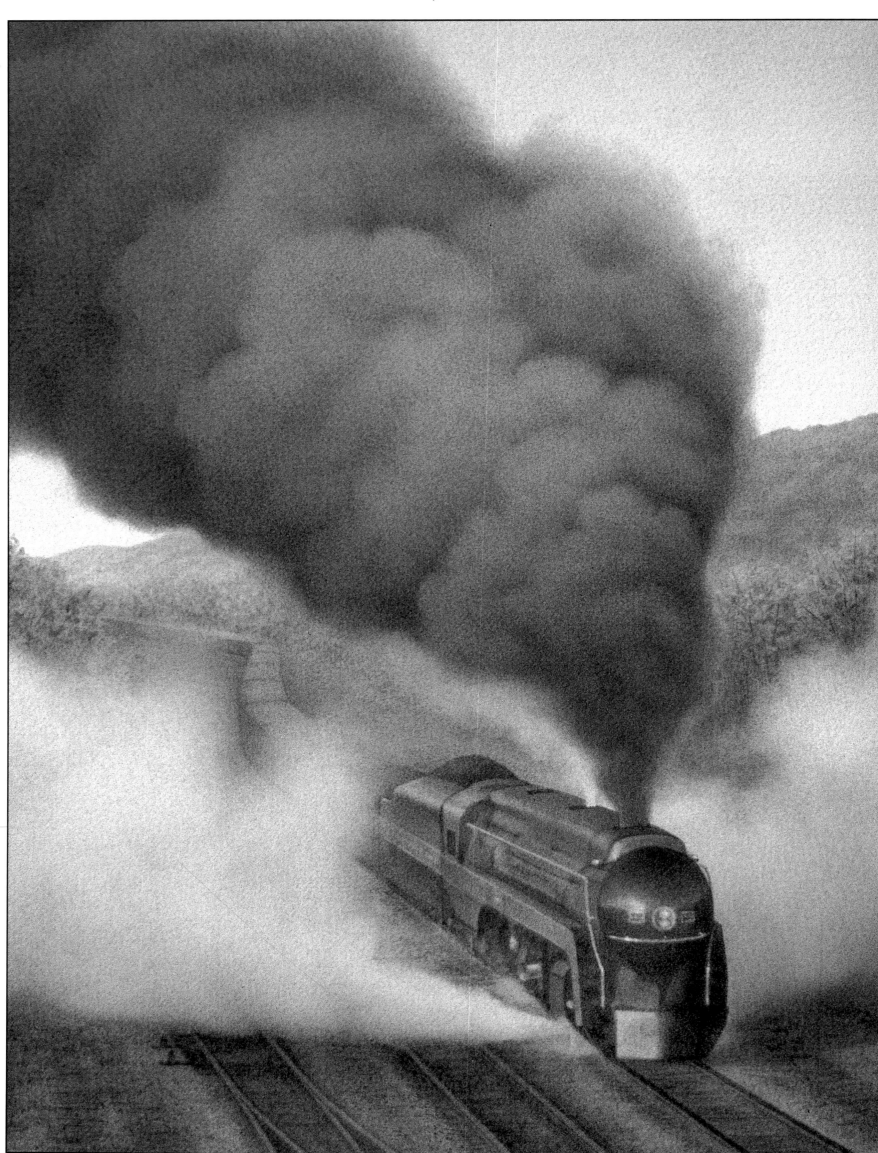

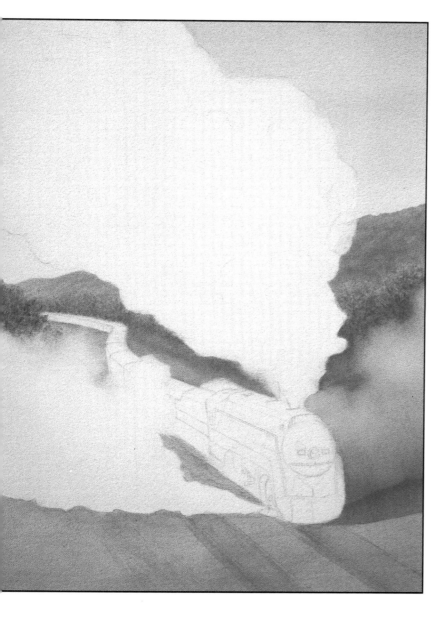

Old steam trains, with their billowing black columns of smoke and great clouds of steam, are fast becoming a thing of the past. In this painting, *Norfolk and Western, Number 611,* the challenge is in trying to depict the softness of the smoke and steam in watercolor.

Paint the background first, taking care to paint around the areas for the smoke, train, and steam.

Next, mix a weak puddle of ultramarine blue and burnt umber for the steam. It should be about the color of dirty mop water.

With a 1/2" flat brush, use this mixture to paint the contours and shadow areas of the steam, blending them with clear water into the lighter areas of the steam.

To soften the outer edges of the steam, work a dampened brush in a circular motion over the edges, scrubbing off a little of the background paint. Then blot with a paper towel and repeat, if necessary.

Paint the smoke with multiple washes of ultramarine blue, burnt umber, and burnt sienna, gradually building up the color. Keep the edges and contours soft by feathering them out with the brush as you go.

Using the smoke colors, paint the dark body of the train. Notice how the hard edges of the train make a nice contrast against the softness of the steam and smoke.

Paint the reddish panel on the side of the train with a mixture of ultramarine blue, burnt umber, burnt sienna, and alizarin crimson. Use yellow ochre for the light.

Finally, use the smoke and train colors to paint the foreground and tracks. Then, as a final touch after painting the ground, spatter a dark mixture of ultramarine blue and burnt umber along the tracks to suggest gravel.

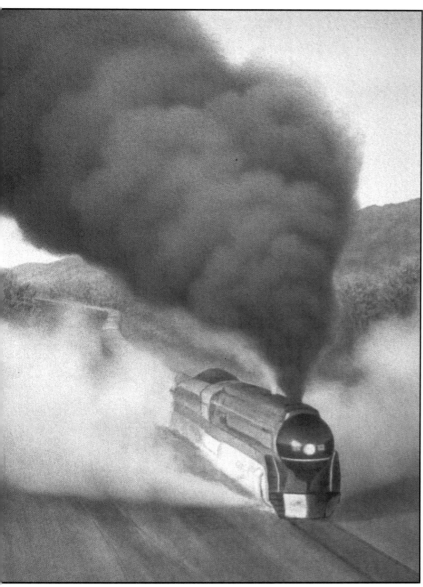

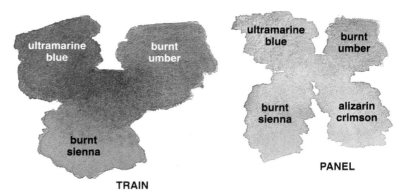

Lesson 10: *BLACKWATER FALLS*

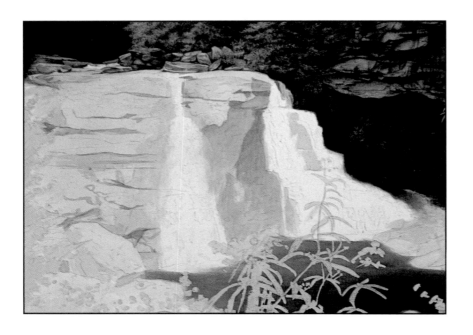
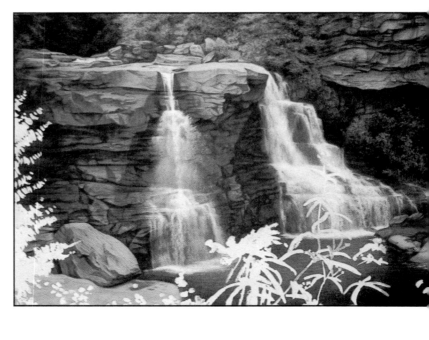

cadmium yellow light · yellow ochre · Hooker's green · ultramarine blue · burnt umber · raw umber · alizarin crimson · burnt sienna

Paint the background trees and rocks first; then apply masking fluid to the foreground flowers and foliage. When the masking fluid has dried, paint several light washes of ultramarine blue and burnt umber on the remaining rocks and rock ledge. Leave the white of the paper for the waterfall area. Continue building up the color on the rocks and crevices with darker mixtures of ultramarine blue, burnt umber, and burnt sienna. With a pale mixture of ultramarine blue and burnt umber, add shadow detailing to the waterfalls. Use a razor blade to pick out any highlights or lost white areas. Paint the remaining water; then remove the masking fluid and complete the foreground.

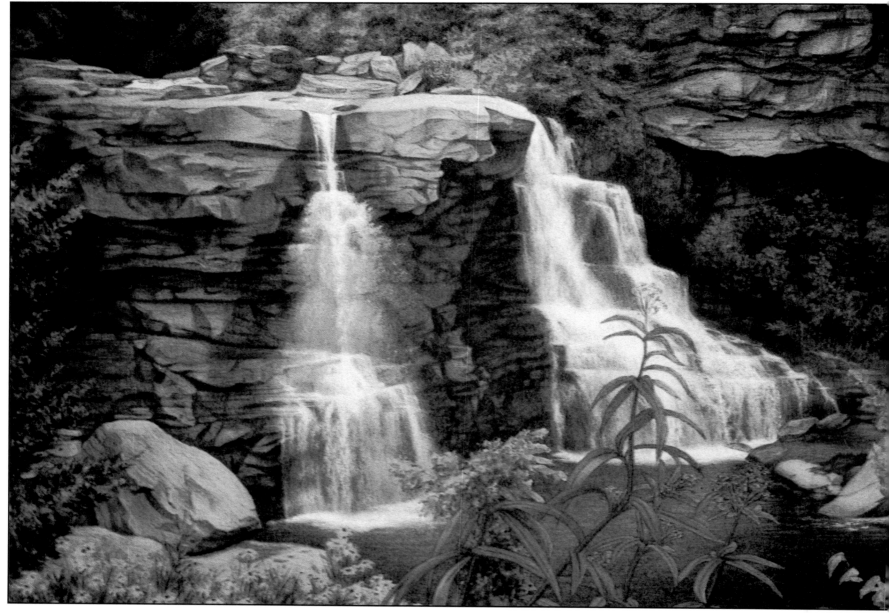

ultramarine blue

burnt umber

raw umber

burnt sienna

FUR

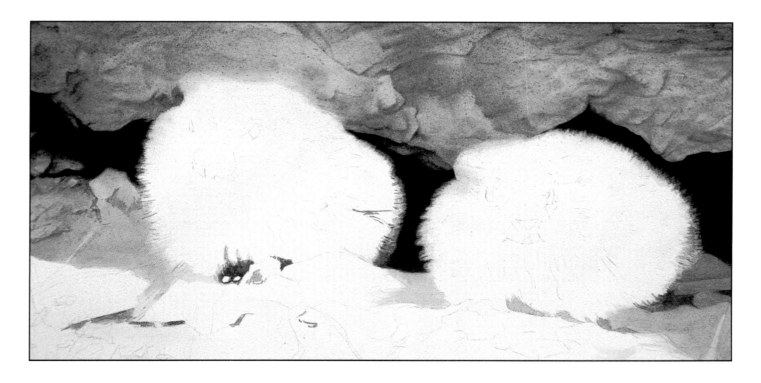

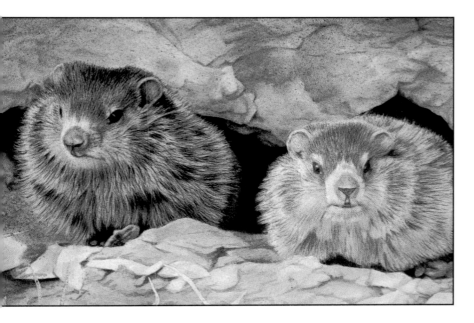

Start with light washes of color on the rock overhang, middle ground, and burrow opening. It will take several layers of paint, drying between each layer, to achieve the dark color of the opening. Also, when painting the background areas around the groundhogs, use jagged strokes, painting into the fur of each animal instead of smoothly outlining around the edges of their coats.

Now paint the fur with a small round brush. Make your brush strokes from the body outward in the direction that the hair grows. Build up the color gradually, as shown, alternating between detailed strokes and light washes and following the dark and light patterns in each animal's coat.

Next, paint the eyes, saving the white of the paper for the highlights.

Finally, complete the foreground area by adding leaves, grasses, and a few pink flowers.

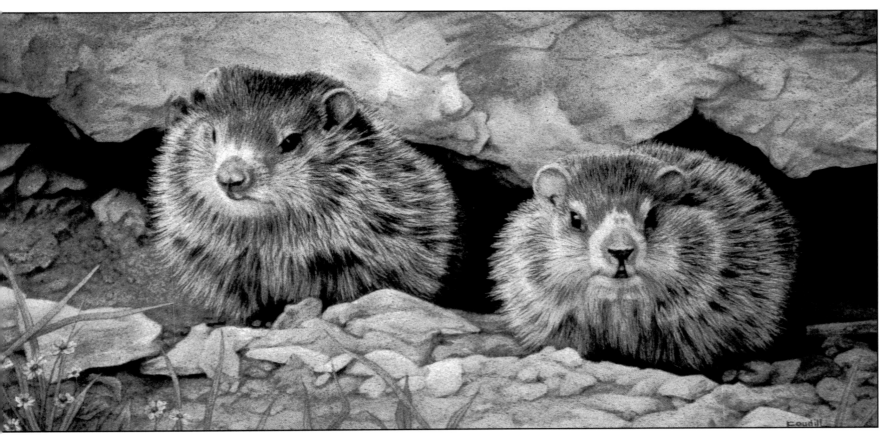

Lesson 12: *FENCEROW DAISIES*

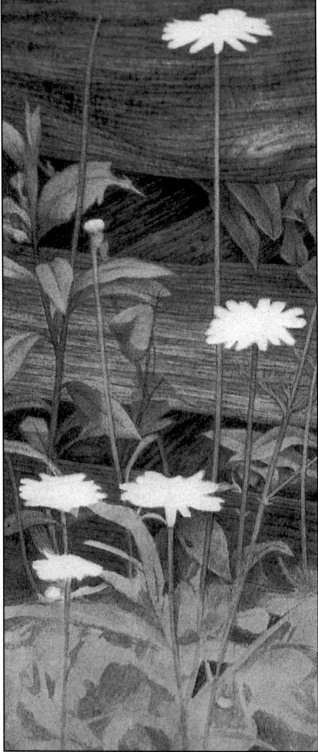

ultramarine
blue

burnt
umber

FENCE

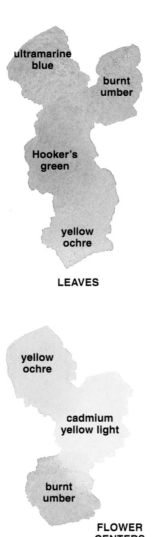

ultramarine
blue

burnt
umber

Hooker's
green

yellow
ochre

LEAVES

yellow
ochre

cadmium
yellow light

burnt
umber

**FLOWER
CENTERS**

Intimate Landscapes

Sometimes fascinating subjects for landscape paintings can be found hiding in the corners of your own backyard. So take a closer look, and you will find many intimate landscapes just waiting to be painted.

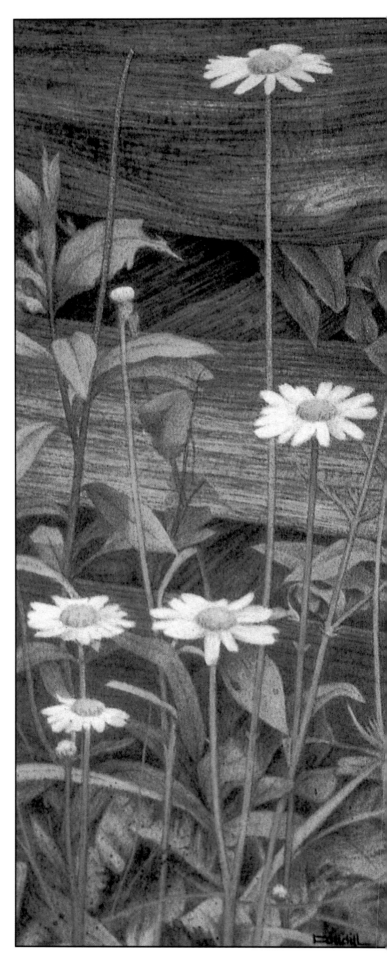

Begin by painting the wooden rails of the old fence, carefully painting around the tall stems, flowers, and leaves (instead of applying masking fluid). Note: Masking fluid is not used in this case because a fluid wash is not required on the fence behind the objects. Also, with their delicate detail, painting around the objects would give a smoother edge to them than could be obtained with the use of masking fluid. Finish the fence, adding texture to the rails by painting in the lines of the wood grain and by scraping off a few highlights with a razor blade.

Next, paint the leaves and stems. Some of the leaves will be lighter and warmer in color where they are exposed to the sunlight, while others will be deeper and cooler in color where they recede into the shadows of the fence and other leaves. Spatter a little paint on the lower leaves and stems for a finishing touch.

Finally, paint the flower centers using yellow ochre and cadmium yellow light, adding a little burnt umber around the edges. Lightly tint and shade the petals with a thin mixture of these same colors.

Detailed paintings like this one and *The Lowly Dandelion* (next page) take some time to complete but are a lot of fun to do.

esson 13: *THE LOWLY DANDELION*

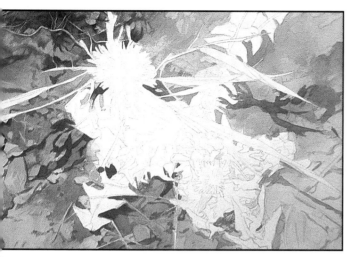

Paint around the flowers and leaves with light washes.

FLOWERS

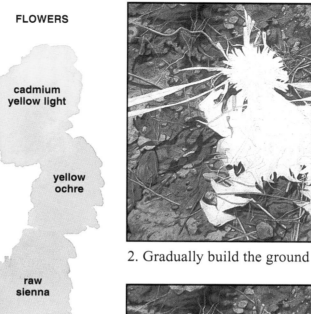

cadmium
yellow light

yellow
ochre

raw
sienna

burnt
umber

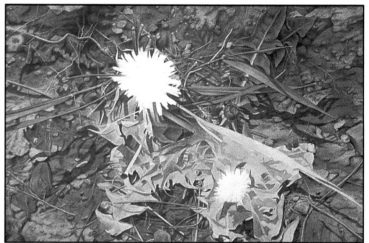

2. Gradually build the ground color, shadows, and texture.

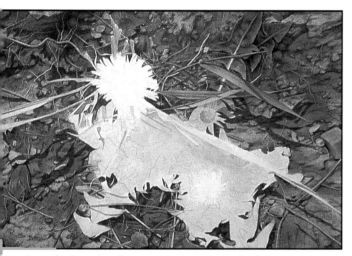

Begin painting the leaves, stems, and shadow areas.

4. Continue detailing the leaves, stems, and the flowers.

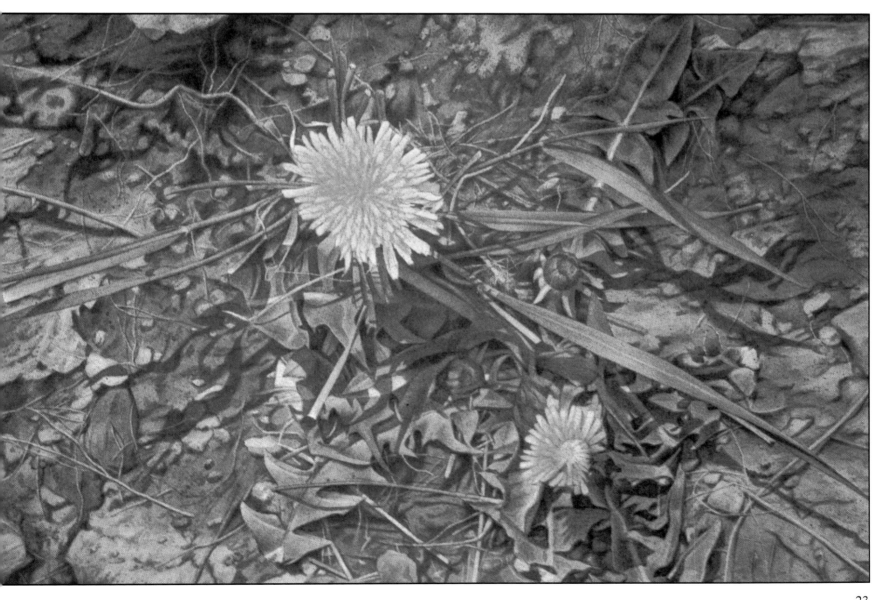

Lesson 14: *THE FARM POND*

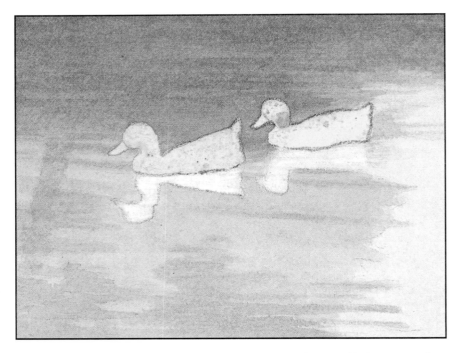

Many rural areas have peaceful farm scenes, such as this one o￼ shady pond on a warm summer day. The two ducks complete t￼ picturesque setting as they quietly glide by undisturbed.

WATER

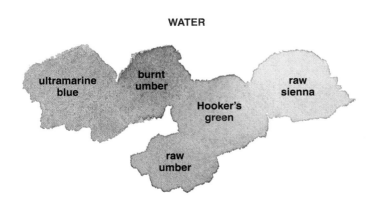

Working from the background forward, paint the small sky area, distant trees, and field, keeping the paint mixtures very light. When this has dried, paint the tin of the old barn roof, again keeping the paint mixture very light.

Next, with a darker color mixture of ultramarine blue and burnt umber, paint the barn, tree limbs, and tree trunks. Add the yellow grasses and fence posts along the top of the bank.

Then paint the foliage on the trees and greenery along the bank with mixtures of ultramarine blue, burnt umber, Hooker's green, and yellow ochre. Add a little opaque white to the mixture for the lighter leafy areas.

Next, paint the two ducks with masking fluid. After the fluid h￼ dried, apply a light wash of yellow ochre over the water, followed ￼ another pale wash of ultramarine blue.

After drying, use broken horizontal strokes to paint the refl￼ tions of the barn, trees, and bank in the water. Caution: Do not pa￼ over the light reflections of the two ducks in the water.

Then paint the rocks and complete the water by making it da￼ er in color near the edge of the bank.

Finally, remove the masking fluid from the ducks, and add ￼ bills, eyes, and light shading on their bodies to model the contou￼

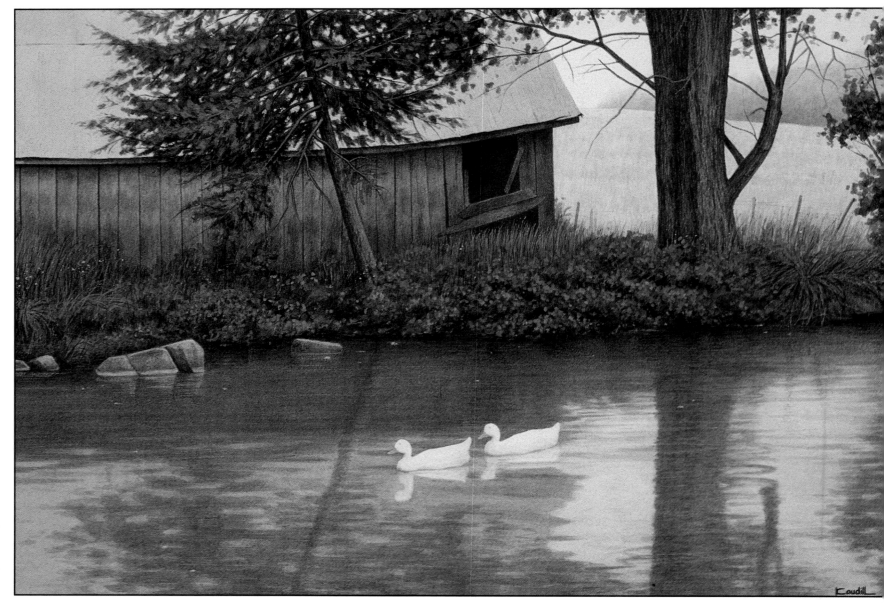

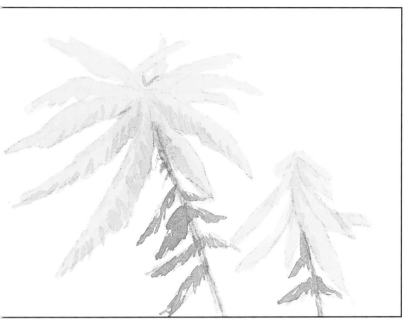

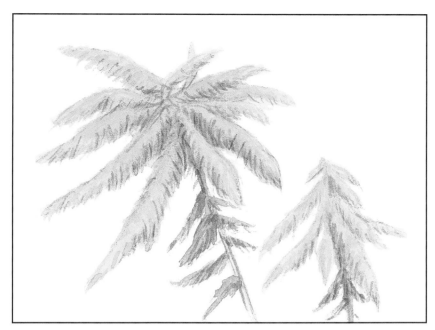

...int the stems and leaves with Hooker's green, ultramarine blue, ...rnt umber, and yellow ochre. When this has dried, apply a wash ...f cadmium yellow light to the flowering part of the goldenrod.

Next, after the last step is dry, define the flowers by adding shadows along the edges of the flower blooms with raw umber, yellow ochre, raw sienna, burnt umber, ultramarine blue, and Hooker's green.

FLOWERS AND STEMS

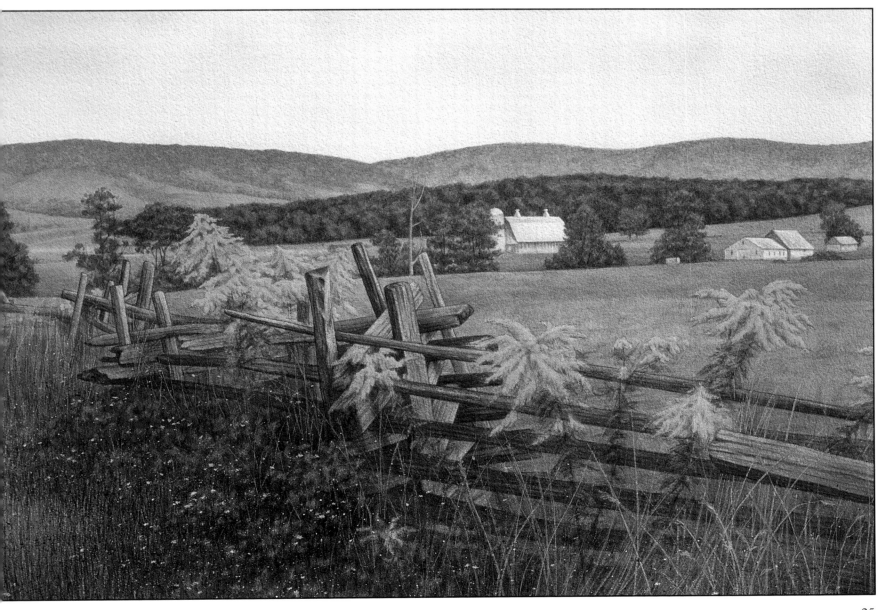

Lesson 16: *AUTUMN SHALLOWS*

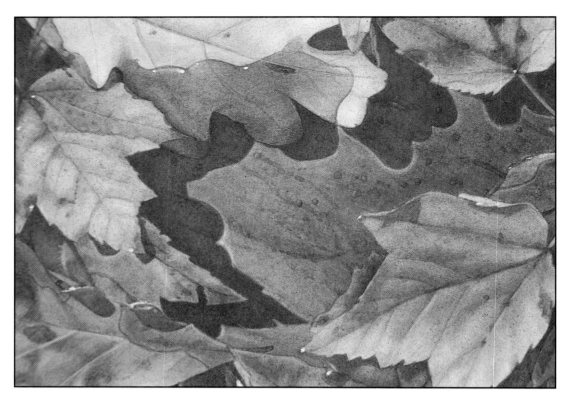

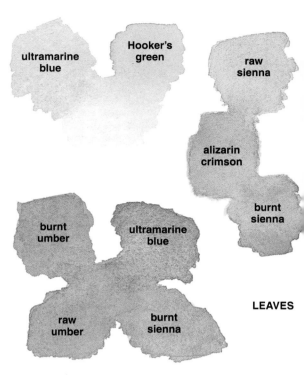

LEAVES

Autumn leaves floating in a shallow mud puddle became the unlikely inspiration for this painting.

Look closely and you will see that some of the leaves float lightly on the surface of the water while others float partly below its surface. Still others are deeply embedded in the muddy bottom.

The floating leaves cast an illuminated shadow onto the bottom the puddle, creating a center of interest among the intricate lacy patterns of the leaves.

When transformed into a painting, you can see how this humble commonplace subject is elevated to a thing of simple beauty.

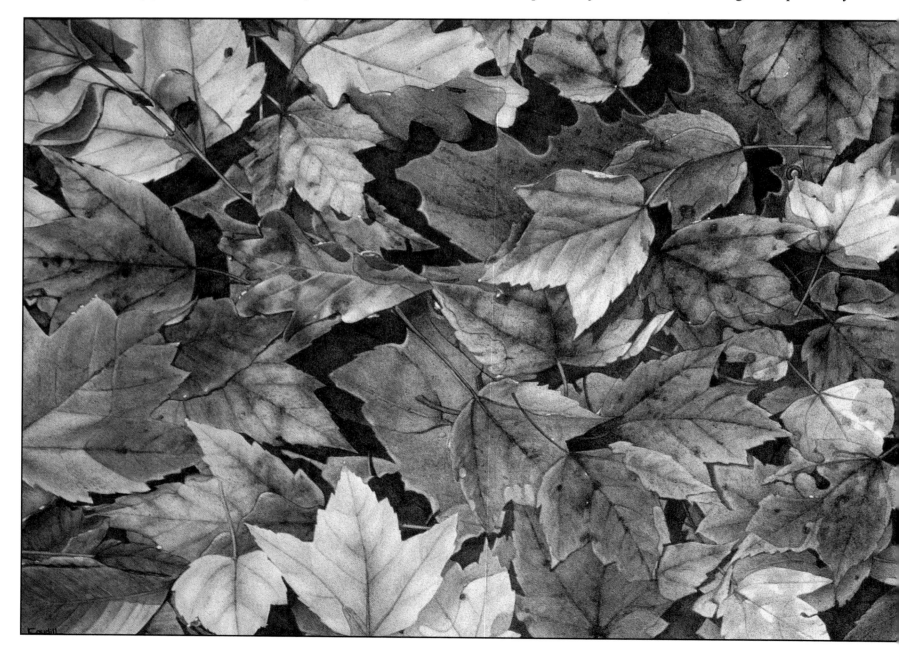

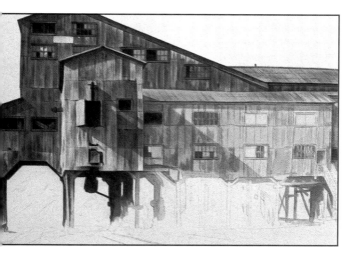

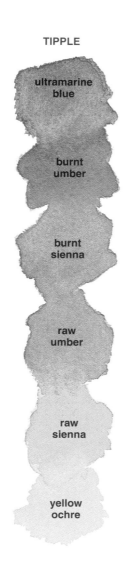

TIPPLE

ultramarine blue

burnt umber

burnt sienna

raw umber

raw sienna

yellow ochre

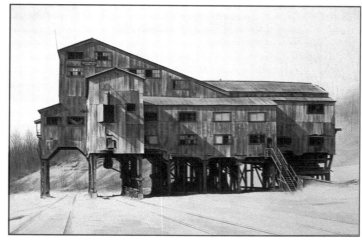

coal mining areas of the country, old abandoned coal tipples are a common sight. Both of the tipples that became subjects for the paintings in this book are located in southern West Virginia. Though most of these older tipples have been torn down or replaced with more modern structures, there are still a number of them left. Their rusty hulking forms and intricate architecture make irresistible and challenging subjects for artists.

Paint the sky first and allow it to dry. Then paint the siding, windows, and roof of the tipple, building color gradually by applying wash over wash, allowing the paint to dry between each application. Take special care to paint around and save the white of the paper for the lighter areas on the tipple.

Next, add details on top of the dried wash areas. Use a razor blade to lightly scrape out the small light areas that were lost during the wash applications.

Soften any harsh areas of paint by firmly pressing a dampened paper towel on the area. This will lift off a small amount of unwanted paint. When the tipple has been completed, apply a yellow ochre wash to the sunlit areas of the roof and siding.

Pay particular attention to the cast shadows on the building. Shadowed edges have the most contrast where they meet areas of light, and they are dark in the corners of the building where there is less reflected light. Also notice that the shadow areas are transparent enough so that the tin siding underneath is still visible.

Now paint in the ground, trees, and railroad tracks using a little opaque white mixed in with the transparent color for some of the tree branches and foreground twigs and grass.

Finally, for added texture, spatter a little paint onto the foreground.

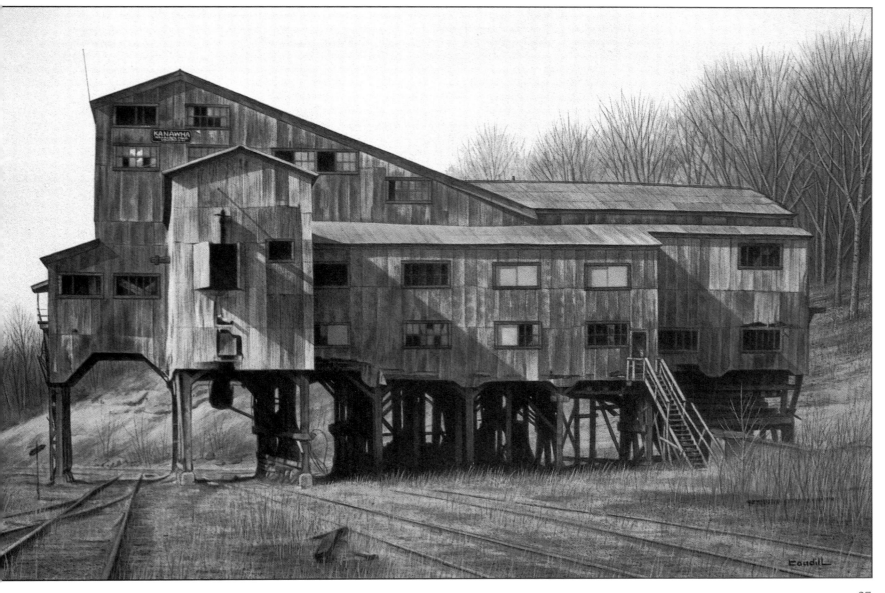

Lesson 18: *CRANBERRY TIPPLE, WINTER*

Cranberry Tipple, Winter makes an especially interesting subject for a painting because of its sprawling construction and the snow on the ground. There is a striking contrast between the dark forms of the tipple and the stark white of the snow. You will enjoy painting this one!

When the sky has dried completely, remove the masking fluid and paint the background trees with a light mixture of ultramarine blue and burnt umber. Dry with a hair dryer, then begin adding color to the tipple. Start with light washes, drying between applications and adding detail as you go along.

burnt umber

ultramarine blue

BACKGROUND TREES

Next, paint the stone building using the same colors mentioned in the last step, but add the stone texture by applying darker paint in short, choppy strokes over a previously dried wash. Finally, paint the foreground, tinting the shadow areas of the snow with a pale wash of ultramarine blue and burnt umber and the light areas with a yellow ochre wash.

raw umber

burnt sienna

STONE

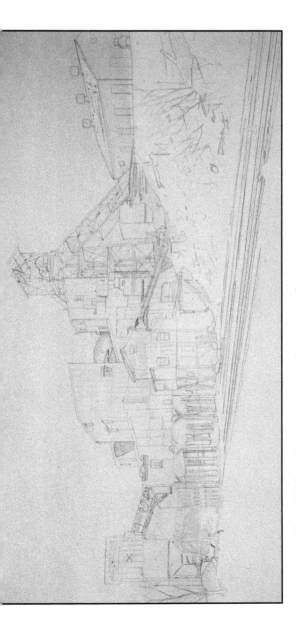

Apply masking fluid to the snow-covered areas on the tipple, the top of the bank, background hill, and tree. Then paint a light wash of burnt sienna across the sky, followed by another wash of ultramarine blue and burnt umber, leaving a streak in the middle of the sky untouched by this second wash.

burnt sienna wash

ultramarine blue and burnt umber wash

SKY

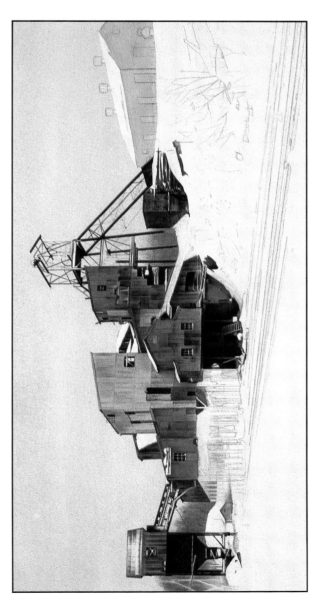

Finish painting the remaining roof and siding areas on the tipple using different combinations of ultramarine blue, cadmium red, burnt umber, raw umber, and burnt sienna. Then paint the shadow areas underneath the tipple and the tower with darker mixtures of the same colors, building up the color gradually.

burnt umber

burnt sienna

raw umber

ultramarine blue

TIN

NEW RIVER WHITE WATER

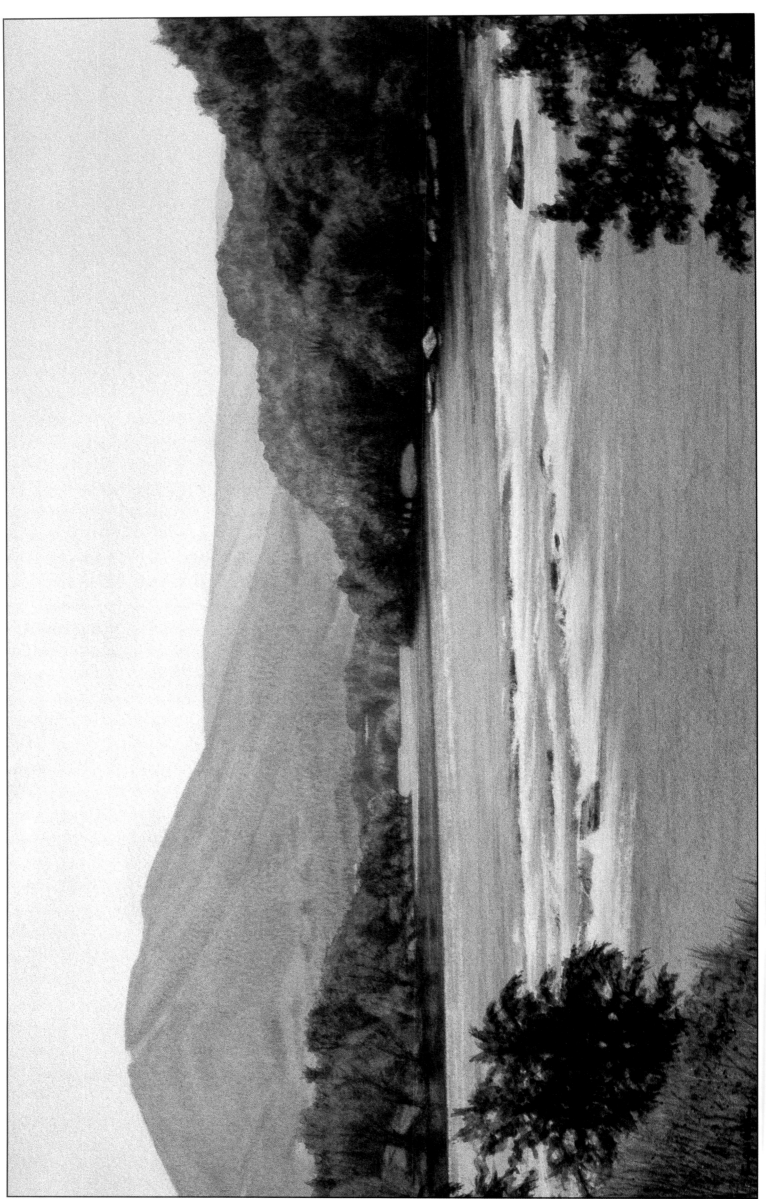

It is not necessary to travel great distances to exotic places to find subjects for painting. Some of the most compelling and interesting subjects can be found in ordinary, often overlooked, places. Simply learn to see with an artist's eye, and a whole new world of beauty will open up to you.

How to Frame a Watercolor Painting

Note: Watercolor paintings should be framed under glass or Plexiglas to protect the painting. Matting is used on a watercolor painting to keep the glass from touching the picture's surface, as well as serving as a decorative edge for the painting.

Attach the painting to the matt with cut strips of art tape secured to the top back of the painting. Also cut a piece of foamcore board or cardboard the same size as the matt for use as a backing board.

Cut the matt board face down with a matt cutter. Note: Several matt cutters are available, ranging from inexpensive hand-held models to large professional cutters such as the one shown here. The cutter will make a beveled cut in the opening of the matt.

Choose matting and framing that will enhance the painting without overpowering the image. The matt colors selected should be neutral or match the colors in the painting. Single or multiple matting can be used. (For further information, see Walter Foster's *The Art of Framing*, AL19.)

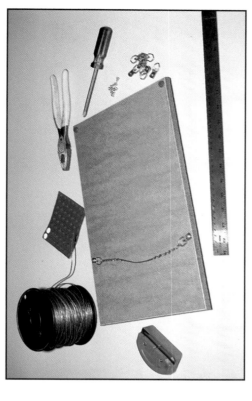

Finish by making a hanger out of picture wire, and attach it to the back of the frame with two screw eyes or D-ring hangers as shown. Rubber or felt bumpers can also be added, if desired, to the bottom of the frame back to help hold the picture straight on the wall when hung.

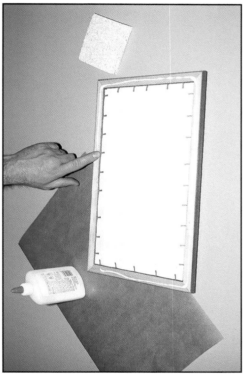

Next, make a dust cover for the back of the frame using craft paper that is cut a few inches larger than the frame. Spread white glue on the back edges of the frame. Dampen the craft paper on one side with water and place the dry side on the glue. Allow the paper to dry and tighten. Then trim the edges even with the frame.

Now place the glass, the matt with the attached painting, and the backing board in the frame (in that order). Secure with brads, push points, or framer's points, as shown. (Be sure the glass is clean—no lint or fingerprints.)

More Ways to Learn

Artist's Library

AL26 — PHOTOREALISTIC PAINTING By Daniel K. Tennant

AL04 — ACRYLICS — Translucent Techniques For Landscape Painters — By R. Bradford Johnson

AL02 — WATERCOLOR By Duane R. Light

The **Artist's Library** series offers both beginning and advanced artists many opportunities to expand their creativity, conquer technical obstacles, and explore new media. You'll find in-depth, thorough information on each subject or art technique featured in the book. Each book is written and illustrated by a well-known artist who is qualified to help take eager learners to a new level of expertise.
Paperback, 64 pages, 6-1/2" x 9-1/2"

Collector's Series

CS01 — The Art of Pencil Drawing — Simple, step-by-step illustrations show how to create beautiful pencil compositions—from still life and landscapes to animals and people. BY GENE FRANKS

CS03 — CARTOON ANIMATION by Preston Blair

CS02 — Watercolors — Covers all the techniques you need to know to create beautiful watercolor paintings of people, landscapes, seascapes, still life, children, and animals.

Collector's Series books are excellent additions to any library, offering a comprehensive selection of projects drawn from the most popular titles in our How to Draw and Paint series. These books take the fundamentals of a particular medium, then further explore the subjects, styles, and techniques of featured artists.
CS01, CS02, CS04: Paperback, 144 pages, 9" x 12"
CS03: Paperback, 224 pages, 10-1/4" x 9"

How to Draw and Paint

HT264 — Starting Out in Oil Painting — with Robert Moore

HT265 — Starting Out in Watercolor — with Caroline Linscott

HT266 — Starting Out Drawing — with Mike Butkus

HT268 — Starting Out in Pastel — with Ken Goldman

Step-by-Step Watercolor — with Geri Medway

The **How to Draw and Paint** series includes these five stunning new titles to enhance an extensive collection of books on every subject and medium to meet any artist's needs. Specially written to encourage and motivate, these new books offer essential information in an easy-to-follow format. Lavishly illustrated with beautiful drawings and gorgeous art, this series both instructs and inspires.

Paperback, 32 pages, 10-1/4" x 13-3/4"

Walter Foster products are available at art and craft stores everywhere. Write or call for a FREE catalog that includes all of Walter Foster's titles. Or visit our website at www.walterfoster.com

Walter Foster™

Walter Foster Publishing, Inc. • 23062 La Cadena Drive • Laguna Hills, CA 92653 • (800) 426